C O N T E N T S

I want to express appreciation for the help Joel-Peter Witkin gave me while preparing this introduction to his work and for making special reproduction prints for the catalog. Many other people and institutions also helped to make possible this publication and the exhibition it serves. Collectors, recognized elsewhere, and two dealers, Jeffrey Fraenkel and Peter MacGill, generously permitted the reproduction of pictures by Witkin in their possession. Special thanks are due to Eugenie Candau who read the introduction and offered valuable suggestions; Patti Carroll, who coordinated all aspects of the exhibition and catalog, including the assembling of the pictures for reproduction, prepared the checklist and the brief biographic entry and bibliographic references; Karin Victoria, who patiently transcribed the introduction as it evolved from brief notes to its present form; and Suzanne Anderson-Carey who created such a striking design for this catalog. *V.D.C.*

To understand or sense what Joel-Peter Witkin is doing, it is best to put on a mask, as one might do during the carnival season, and go amongst the strange players in his surreal world. William Blake said that "man was made for joy and woe." The tale-teller Witkin evokes both with deftness, exploiting the printing technique he uses to maintain a slight sense of distance so that a thing his camera has recorded is not too exactly itself. Through his photographs he gives us an opportunity to infiltrate an alien land like an undercover agent.

Witkin's artistic stance involves an act of brinkmanship; his slightest misstep would give away the game he plays with us, that is, the evocation of the fluctuation of space and time in nightmares. The scenes he places before us set off tremors that reverberate all the way to our nerve ends due to their relevance to our present anxiety-ridden times. His work is hard on many people's sensibilities for he sears us with the fire of taboos and the implications of madness.

On first encounter, Witkin's photographs seem to partake of the world of "adult" films and magazines. They are not, however, smut or pornography but, for some, are erotic. Artists have created erotic imagery in all periods and in all cultures. Today there is frank admission that sexual reveries are a part of everyone's life. As Richard Goldstein has said, "What we want, in these moments of escape from tangibility, is excess and extremity." This is what we find in many of Witkin's works, events treated as a form of theater. He recognizes that suggestions are more effective than explicitly detailed records of sexual practices. Many people live their lives ignoring or at least not confronting the sexual activities that go on in all societies to satisfy libidinal impulses or to relieve the tedium of dull everyday lives.

Many Western societies have attempted to repress severely the instinctual drive to satisfy this urge or curiosity about unconventional sexual exploits. In Catholic countries before the dreary period of Lent, carnivals take place during which much that will be suppressed spills out. The content of fantasies becomes reality but not the reality of pornography.

Is Witkin's work pornographic? This question must be raised, but examination of his photographs leads to the answer that there is a mystical and even darkly spiritual quality to his pictures that is quite at odds with pornography. Pornography is intended to arouse lust immediately, not after contemplating a picture and thinking about its many implications. Pornography is a substitute for actual experience and tends to trivialize and focus narrowly the sexual urge. Witkin recognizes this strong universal urge and defines its manifestations in broad uninhibited ways, but the results have esthetic as well as emotional power. Pornography lacks the first and deals with the second in a superficial fashion. By his allusions to art history and his reinterpretations of classical symbols, he signals the seriousness of his intent.[1]

When thinking about Witkin's work, we must take into consideration that there is today, and has been for a decade, a new climate for erotic and fantastic imagery. This is substantiated by the editors of *Variety*–the leading indicator of activities in films. Statistics show that by 1982 nearly 50% of all major films were supernatural horror films or science-fiction films. Add these to the avalanche of increasingly sophisticated porno films and the ready availability of videotapes and recorders with which to play them, all of which makes for a very wide audience being exposed to this kind of imagery.

The mention of a few of the well-known films in this category that were widely shown during Witkin's period of development could start with Roman Polanski's *Rosemary's Baby*, 1968, in which Mia Farrow plays a young mother psychotically bent on killing her child whose father is the Devil; Frederico Fellini's *Satyricon*, 1969, featuring grossly fat women and lots of less filled-out bare flesh and erotic moments, mostly homosexual; and William Friedkin's *The Exorcist*, 1973, which deals with a young girl demonically possessed.

These films do not have raw scenes of sexual sadism or human mutilation like hundreds of well-attended film productions shown all over the country, nor do they dwell on violence to the body. There are, however, many films shown today that deal with some of the same types of things Witkin includes in his photographs. Also not to be dismissed when considering the climate for this sort of thing are Andy Warhol's films, or films inspired by him such as *Andy Warhol's Frankenstein*, 1973, a particularly nasty porno fantasy film directed by Paul Morrissey and shown for weeks in New York and other large cities.

Also keep in mind that only a few years ago the most powerful and successful play on Broadway was *Marat-Sade*. Hermann Nitsch performed the blood rituals of his Orgien

Mysterien Theater in this country several times from 1968 on in such widely dispersed cities as Cincinnati, Los Angeles, New Brunswick, and Binghamton. Further, in a recent Sunday review in the Arts and Leisure section of the *New York Times,* a headline read: "Dancers Who Probe the Dark Corners of the Mind." Called Sankai Juker, this style of dancing originated in Japan in 1975. The reviewer observed that the dances were designed to be "shocking and grotesque to create powerful images...infused with movement, meticulously choreographed and carefully manipulated that scramble the emotions. Heads shaved and bodies powdered...the company's five men...look not quite human. They writhe, roll back their eyes and grin demonically."

Across the country on the same Sunday in the Review section of the *San Francisco Examiner & Chronicle*'s Review section, a so-called "family" newspaper, the headlines for three book reviews on two adjacent center pages read as follows: "When Dreams Turn into a Nightmare"; "Haunted by Violence"; "Macabre Tales of Fear and Horror."

It is instructive to know additionally of Witkin's background when judging his work. In 1970, he began the series of photographs given the name *Insurrection* for they were personal revolts against the idea of mysticism. The pictures objectified what his mind imagined. This series started on the grandest scale to deal with God and Woman. He has said of these pictures, "They are concerned with the fear of my being, the unknown of myself." To understand them, we must be aware that his psyche was severely shocked when he was six years old. He recalls, "It happened on a Sunday when my mother was escorting my twin brother and myself down the steps of the tenement where we lived. We were going to church. While walking down the hallway to the entrance of the building, we heard an incredible crash mixed with screaming and cries for help. An awful accident had taken place involving three cars, all with families in them. Somehow, in the confusion, I was no longer holding my mother's hand. At the place where I stood at the curb, I could see something rolling from one of the overturned cars. It stopped at the curb where I stood. It was the head of a little girl. I bent down to touch the face, to speak to it–but before I could touch it–someone carried me away."[2]

Witkin feels this experience influenced his turn as a photographer to subjects involving violence, pain, and death, and his recurrent bruising dreams. In his mid-teens he, like most thoughtful teenagers, was seeking answers to life's riddles. He was more confused than most young people for his father was an orthodox Jew and his mother a Catholic. His parents had divorced due to religious differences. He lived with his mother but also kept in touch with his father. Both sides of the family had little money for much beyond the essentials. This explains in part why we find in Witkin's photographs echoes of a sense of deprivation and insecurity.

In the mid-1950s, Witkin obtained a twin-lens reflex Rolleicord camera which he learned to use by reading books on photography. His first serious photographic effort was to make studies for his twin brother who was studying painting and had taken for his subject freaks at Coney Island. The pictures Witkin took were of a three-legged man, a dwarf called "The Chicken Lady," and a hermaphrodite, with whom he had his first sexual experience. The freak show was fascinating to him, but it moved south soon after he discovered his empathetic response to the unusual people in the show. In the late 1950s, Witkin not having available freaks to photograph fabricated environments where he directed strange events to take place, which he then photographed. Sources for his imagery came from looking at reproductions of paintings. Rembrandt was a favorite, for Witkin felt he made the sacred human. The late nineteenth-century Symbolists, Felicien Rops, Gustav Klimt, and Alfred Kubin, attracted his attention for their concern with dreams, perversity, and satanism, challenging that which is sacred. Balthus and Max Beckmann, for the erotic and the voyeuristic qualities in their work, also meant much to him. In addition, comic strips depicting contemporary myth-heroes played a role in shaping his imagery. Superman was to him the hero of goodness, the secular Christ; Batman was the Lord of the Bird World and Darkness, the Anti-Christ; Wonder Woman, the Amazon who was related in his mind to the Virgin Mother. Out of this mix he concocted the very romantic notion that he wanted his photographs to be as powerful as the last thing a person sees or remembers before death.

In 1961, he began working full-time as a printer of color photographs but managed to attend evening classes at New York's Cooper Union School of Art as a sculpture major. An example of his work in this medium is the female torso with big breasts, a piece in plaster. His intent was to give separate parts of the body an emphasis based on his

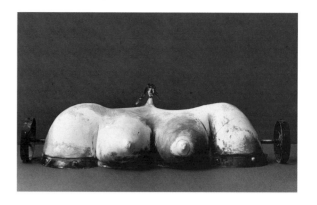

Woman
1970
plaster, tempera paint, steel, 4½ x 14″ (11.4 x 35.5),
Courtesy of the artist
(not in exhibition)

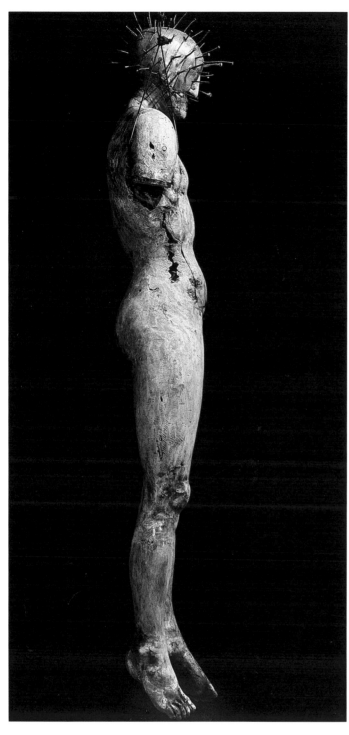

Corpus
1971-74
kinetic sculpture, plaster with tempera paint and nails,
80 x 23½″ (203.2 x 59.7)
(not in exhibition)

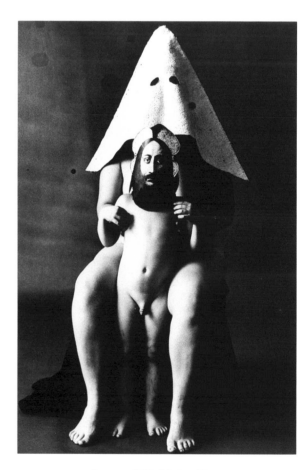

Jesus and His Mother Mary:
Photographed by an Anonymous Galilean Photographer
1974

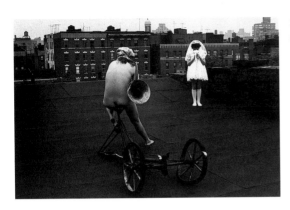

Untitled

1972
from the *Rooftop* series, gelatin silver print,
4¹⁄₁₆ x 6⅞″ (10.3 x 17.4), Courtesy of the artist
(not in exhibition)

interests. He liked breasts more than the head, less from a macho standpoint than from a romantic one. He added wheels to convey a sense of mobility even though the piece can't roll—a paradox that he created intentionally (page 8). Another piece of sculpture, done in the early 1970s, was a six-and-a-half-foot-high Christ with handmade nails from Spain driven into the head. It was made expressly as a tabernacle. In use, the figure of Christ was lowered from above to eye level. The priest then opens up the chest cavity where a little child holding an orb is found. He then takes the orb out of the child's hand, incorporating him as a kinetic part of the sculpture as he consecrates the Host inside the orb. After communion, the utensils used to distribute the symbolic bread and wine are returned to the cavity in the piece. It is closed and raised above those taking communion, becoming a symbol of resurrection as it gradually ascends (page 8).

Because he was not a full-time student, Witkin was drafted into the Army during the Vietnam War. In order to continue photography, he enlisted for three years and began training to be a combat photographer. Two years were spent working in twenty states and Europe assigned to different airborne and combat divisions. One of his assignments was to document forms of death; he photographed deaths resulting from accidents on maneuvers and suicides.

After he left the Army, Witkin's ambition was to make photographs that would help him better understand himself. He set as his goal the grandiose task of creating the image of God. He has said, "In order to know if I were truly alive, I'd make the invisible visible! Photography would be the means to bring God down to earth—to exist for me in the photographic images I would create. I believe that all my photographs are incarnations, representing the form and substance of what my mind sees and attempts to understand. I believe that Christ was a man who transcended this bodily form and became God; or to put it in terms of my personal belief—God placed on the man called Jesus the mask of Christ!"

The first image Witkin made of Christ was created in a slum in Philadelphia. Represented is the coming of Christ into the world. Like the famous Victorian photographer Julia Margaret Cameron, he was concerned only with the expression of his feelings and not with historical accuracy. For example, in Mrs. Cameron's *The Return from the Temple*, she showed Jesus as a four-year-old, rather than the twelve-year-old boy described in the New Testament. Witkin recalls, "In place of a baby coming into the world, I used my brother's five-year-old son who was stripped of his clothes on an abandoned street of the slum. His face was then powdered white, and he was given a dead bird to play with. I photographed this child as he reacted to the environment, the dead bird which he held, and the various reactions of the people watching from windows and curbsides."

Because they provided seclusion, rooftops later became a stage for his "events." Seclusion was important for the people he photographed were physically unusual and could, while being photographed, attract a crowd (page 9). For instance, one of his Mary subjects was a 200-pound extra in porno films. In these photographs he took pains to establish as many irrational encounters as possible. He photographed on a rooftop Christ at the world's end, exhausted and defeated by Batman, the Anti-Christ, Lord of Birds and Darkness. A typical example of his pictures at this stage shows a young nude boy wearing a Christ mask standing between the legs of a seated, nude Virgin Mother. It is titled *Jesus and His Mother Mary: Photographed by an Anonymous Galilean Photographer* (page 8). The *ecce homo* of this series is Christ as a homosexual, which mocked the Church's stand against homosexuals. His "Christ-Homosexual" wears nothing but Japanese World War II kamikaze flyer's goggles and a woman's spiked high-heel shoes!

He intended his images to repel and shock. Even so, he also wanted his photographs to have tender and enlightened qualities which would be emotionally moving. Symbols such as ladders, black clouds, masks, and severed heads were prominent. He has admitted that, "I am a person who could relate to human beings as a human being, but visually I continued to relate to people mainly through symbols. I understood that my images were a kind of automatic writing, the feedback of my consciousness." Life and death were at this time the most profound mysteries for him. His ambivalence toward women was often objectified photographically by the use of a sadomasochistic symbol—bondage. As in the *Contemporary Images of Christ* series, he used masks so that the personality of the subject would not interfere with the meaning of an image. The images from Witkin's *Images of Woman* series represent a melding of the peaceful and the sinister. As real experiences in life, these two attitudes represented the condition of his mind at that time.

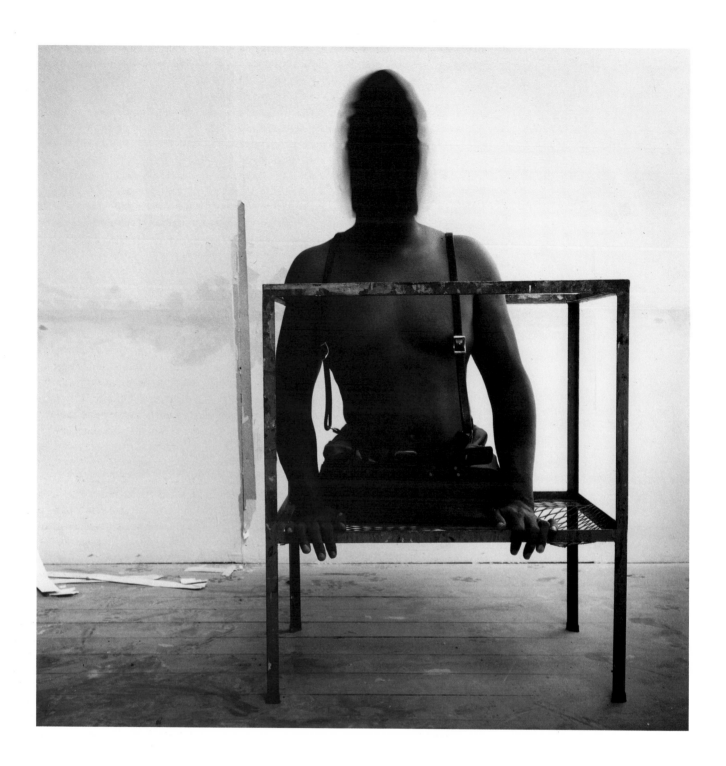

Leo

1976
gelatin silver print with toner, from the series,
Evidences of Anonymous Atrocities
11 3/16 x 11 1/16″ (28.4 x 28.1), Courtesy of the artist
(not in exhibition)

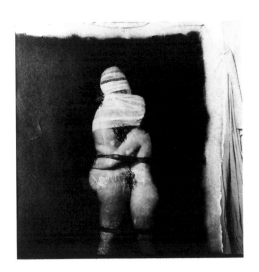

Two Women Bound
1975

The first images of the series were soft, representing romantic allegorical themes. As in the *Christ* series, he first made sketches based on an image in his mind. He then walked the streets of New York City to find the right subject for his work. When he found a subject that suited his preconceived notion of what a woman should look like, he would make detailed drawings of her in an environment he had already created.

Witkin recalls, "I created a true photo-physical metamorphosis in which my fantasies were manifested by the most voyeuristic and perverse means. I placed 'Woman' in coffins, glued leaves on their bodies, had them respond to phallic fetishes, tied, bound and masked them—all in the same hope as in the 'Christ' series, that hope being my personal 'Revelation,' the end of all my doubts, confusion, and pain."

In 1975, Witkin began graduate studies in photography at the University of New Mexico in Albuquerque. He welcomed the opportunity to leave New York, after almost eight years of work, for an entirely different part of the country where there was open space, clean air, and sunshine. When he left for Albuquerque, he carried two cases—one with his cameras, the other containing his collection of masks and leather belts for binding (page 11). At the University of New Mexico he became acquainted with other serious photographers and began the formal study of the history of art and photography. Both expanded his outlook. Many intense discussions of work and ideas with faculty and fellow graduate students encouraged him to investigate the possibilities of focusing on more humanistic and contemporary concerns. The images that resulted were more objective, more about what other people feel. The people he used as models responded to ads placed in local newspapers. He would interview them and show them examples of his New York work. Witkin was seeking people who seemed to be "damaged" and malleable, and he hoped they would reveal their pain to him in the photographs he intended to make of them. His aim was to record real feeling in real time rather than the fantasies of his models. To achieve this he went to extremes such as belting, hooding, and nailing a claustrophobic man to a wall, to whom he bound a woman who only the previous week had been released from a local mental institution. The emotions evoked in the subjects gave the images a visceral quality that was much stronger than anything acted out from a script. Seeking authentic responses to stressful situations was exciting, but he began to realize that what he was doing could damage his subjects as well as his own psyche. In one case he placed in a cage a muscular black man born with no legs—leaving him there masked and helpless while Witkin sought to find "truth" in the viewfinder of his camera (page 10).

Upon reflection he tried a method of creating images after his first year at the university which was the opposite of his previous approach. He left the studio and began photographing in bright sunshine, without the use of a tripod, so that the camera would be an extension of his body and his mind. He could not plan his images for the subjects were in flux. An example would be dead birds thrown above his head and caught in mid-air as if brought back to life. He then decided to include in his pictures small rubber toys—one, a woman's head (perhaps recalling the dead child's head he had seen as a child), and the other, an alligator. He bound them together so that the alligator wore the head of a woman. During his summer vacation from the university Witkin spent several weeks in Hollywood making hundreds of images using this object. The object was held at arm's-length close to a 28mm wide-angle lens, which was set at infinity to catch the surrounding environment. No people were included in these pictures. He was very pleased with the negatives made in this way. One of them, called *Los Angeles Death* (page 13) had in it the image of a woman who had suddenly appeared in range of his camera while he was in the act of shooting. He recalls, "This woman's *physical form*, especially the way in which it was cut in half by the frame 'made' this image for me—but her *presence* was disturbing. She was now part of an 'incident' I had created, and also a 'witness' to it. She had observed me symbolically inflicting pain onto the object I had made by attempting to strangle it. This object then became a symbol not only of the image, but of my *sadism*. I had been caught in the process of inflicting pain. In all my previous work, the viewer could never know that I had either caused or renewed the pain and suffering which I presented as photographic prints. This image proved it!"

For reasons he does not understand, he felt he had to remove all evidence within the picture that would "incriminate" him, but at the same time he felt he must make a print of this negative because it was for him such a strong and moving image. He therefore scratched out the woman's face with a needle on the emulsion side of the

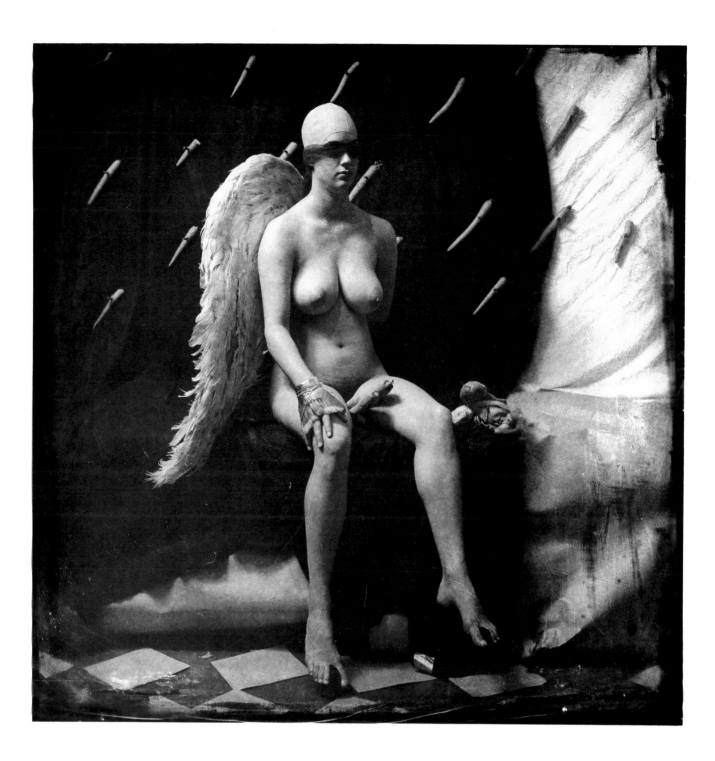

Angel of the Carrots
1981

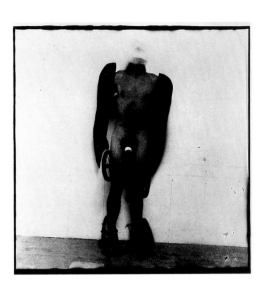

Man with Wings and Wheels
1979

negative and also used this same technique to eradicate the feeling of a specific place by scratching out a portion of the negative that included two billboards.[3] This allowed him to change the image for his own emotional and esthetic purposes. He began to see that he had "the ability to objectify emotion materially, so that the final physical object, the photograph, *is* that emotion visibilized... they reveal *what* was photographed, and *how* it was photographed, and, later, what was changed, and in doing so, they are the physical translations of unconscious experiences, thus becoming new forms of the indescribable."

The next series was again about emotions. He would place a mask on a model in order to get away from a specific personality. Masks became more and more important elements in his future work. He felt he was making a visual examination of his own mind. He sought to photograph the unknown in himself—the fear of his being—in the hope of facing it and thereby being emptied of it. To give himself a clearer concept of how his idea could be carried out, he began to make sketches of the images he had in his mind. He maintained simple technical procedures. The lighting in his studio is north light, which he prefers. A single strobe light may also be used. The placement of highlights and the general distribution of tones are modified a great deal in printing, so lighting is not a major issue with Witkin. After a negative is exposed and developed, he makes a contact print and studies it to determine where markings will appear, where to mute a passage, or where he wants clarity. To make an exhibition print, he places a piece of very thin tissue on his photo-paper to increase light refraction and soften an image, or he punches holes in the tissue to create selective areas of sharpness. After the tissue is laid on the photo-paper, it is sprayed lightly with water to cause it to adhere to the photo-paper and to make it more translucent. Recently he usually uses the tissue in its normal, flat state, crinkling the edges only.

Before a print is made, he makes scratch marks on the emulsion side and even at times on the opposite side of a negative. He prints on warm-toned paper that reflects well the marking and muting he feels are appropriate for a specific picture. When processed and dried, his prints are toned, often with two toners. The brown/yellow glow in his prints, created by toning, conveys the feeling of a patina brought on by age or recalls the look of parchment or fine old rag paper from past centuries. This old-masterish look gives even the most outrageous image a sense of history. It is as if his photographs had been put away in a musty cabinet for years and only recently rediscovered. This makes possible a

Los Angeles Death (formerly *Untitled [L.A. CA.]*)
1976
gelatin silver print, from the series, *Objects Held and Thrown*, 8⅜ x 12⅝" (21.3 x 32.0),
San Francisco Museum of Modern Art, The Helen Crocker Russell and
William H. and Ethel W. Crocker Family Funds Purchase 80.186
(not in exhibition)

more oblique approach to his bizarre subjects than would be the case if he used a straightforward printing technique. The sense of age tends to temper the shock of encountering even the most dramatic events. The result is like an image seen in a soft mirror as reality and fantasy are joined in our mind by his printing and toning techniques.

The genesis of Witkin's complex imagery is not shrouded in mystery for he has freely recounted incidents in his life that have set in motion the ideas used. He wishes us to know what is behind his work for he believes in communicating his interpretations of the special world he has come to know. His pictures range from searing to zany–not that he intends to be a modern-day Charlie Chaplin, but some of the antics he records with his camera *are* like vaudeville sketches. He wants everything to be symbolic and sometimes fabricates preposterous scenes to give his idea a greater sense of immediacy. Witkin's explanation of how he created a number of images in this exhibition with his comments, far ranging as they may be, on their meaning give us a clearer idea of his aims and the means by which he has achieved them.[4]

One of Witkin's memorable earlier photographs is *Mother and Child* (page 20). He comments on this 1979 picture: "The model had been wearing orthodontics for most of her life. I had known and observed her before I decided to photograph her and her new child and to include in the image her sensual body and that armored mouth which I fantasized would make a flayed martyr of some deserving man. I called her. She told me of her great joy that finally the orthodontics were to be removed! I convinced her to delay their removal until I made the photograph. A dentist lent me surgical retractors. Their purpose was to force her mouth to stay open while holding the child. During the photographic session I found that the retractors could not supply enough stress to hold her mouth open to the extent I desired. I therefore had her sister (who came along to care for the needs of the baby) put on long black gloves and located her in the black background so that she could force her sister's mouth open to its extreme. The concept of this image is the pain, the wonder, the mystery of having a child...of having ourselves. There is symbolism too when a woman gently places her fingers near her child's penis. We see this in Renaissance paintings of Christ and his mother, calling attention to his virgin manhood."

Woman Breastfeeding an Eel (page 21) was also taken in 1979. In this picture he wanted to create a photo-booth type of situation. "My reality was of a very voluptuous woman finding herself walking, let's say, into a K-Mart with an eel and posing in front of an automatic coin camera behind a curtain. I wanted to be that machine. The picture was made in the wintertime in New Mexico when it is very hard to get an eel. However, I acquired one through suppliers of gourmet food for the restaurant where I was working as a waiter. The scratching in the background I drew in with chalk before the exposure. Later I also added scratching in the negative. It connects with this internalization quality that interests me–that is, people putting things in their bodies or to their bodies. It's a form of personal dialogue that is inaudible in the sense that they're feeling sensations. My problem is to also feel those sensations and visually make them happen in a photograph."

Witkin recalls that, *Angel of the Carrots,* (page 12) 1981, was photographed at the time he was thinking about *food* that could also be used as physical stimuli. "The important thing for me is that it's stimulating when a person puts something in a body, whether it is into another human being or themselves. That form becomes part of them, a silent dialogue takes place. In this image she is actually placing the tips of the carrots in herself. Used were large carrots I had purchased an hour before at a health food store."

Mandan, (page 35) done in 1981, is derived from a George Catlin painting. Witkin comments: "Like *Penitente* (page 23) this image is about self-realization, but has an altogether different reference because it was done by Indians. The person photographed for the picture is a man who lives in San Francisco. I went to the man's house where he showed me in his garage the elaborate rigging he uses to help him carry out his performance during which he elevates himself with rope connected to hooks inserted in holes in his chest muscles. He began making holes in his chest muscles as a boy and progressively widened the holes with pieces of bone which were worn under his clothes. This was the beginning of his way to get closer to the origins of life."

A marked change in subject matter took place when Witkin created the picture *The Wife of Cain* (page 25) in 1981. He says: "My object here was to convince a very beautiful pregnant bellydancer to pose with a fetus. I talked with her, showed her my drawings, and explained why I wanted to use a fetus with her. She agreed and said she didn't mind being photographed while she was pregnant. In the process of making the image I strapped a

skeleton from a university art department drawing studio to her back. She said I could use a live snake in the picture also, but suggested that I cover the ribs of the skeleton because the snake might go in there and hurt itself. All this became part of the image. The mask came from Batman. My model has a very beautiful mouth, but I didn't want the person in the picture to have a beautiful mouth. After the exposure was made I scratched the negative, but in doing so I lost the whole mouth and part of the nose so I had to reconstruct this with gelatin and glue. I had done the *Expulsion from Paradise of Adam and Eve* (page 33) so I felt the *The Wife of Cain* should come next. The image echoes my own need to visualize what I'm *told* about, whether I accept it or not as a belief system. I always want to see the world for myself. And the best way I can do this is through my work."

The *Bird of Queveda,* (page 42) 1982, came about when a friend of Witkin's found an owl on the road while driving in the New Mexico mountains. He takes up the tale: "My friend very respectfully took the owl back, removed the talons and the wings, took the body, wrapped it up, put it in his basement in a freezer, locked the door to the basement with the idea that the next day he was going to bury the body. Early the next morning after starting coffee, he opened the front door to his house in order to get that day's milk and newspaper. But there was another item on the steps...the still wrapped warm body of the owl! He immediately drove back to the mountains and buried it. On returning home, he fashioned a small altar to the spirit of the bird using its talons and wings. When I saw this display and heard the story, I decided to use these mystical elements not only to change a woman into a bird but also to be incoherent with wonder of how it would be to find among the relics in an attic a daguerreon case, to open it, and be consumed by a visage of the ineffable."

His staccato explanation of the picture *La Brassière de Joan Miró (The Bra of Joan Miró),* (page 30) 1982, is: "I feel one of the most wonderful as well as nourishing things about the female body are breasts. In this image I combined the structuring of some of Miró's forms to show how the mammary glands of a woman become transfixed. I was interested in how we change our bodies by what we wear. I would displace the eyes of her face as the bra of Joan Miró would displace the 'eyes' of her body. She shaved her pubic hair at my request since this was important to the formality of the image and as a tribute to Miró, who for me has always been the unblemished saint of contemporary art. At the time this image was made I was doing research about the history of bras and corsets."

I.D. Photograph from Purgatory: Two Women with Stomach Irritations, (page 40) 1982, is one of his eeriest images. Witkin explains what he had in mind: "One of these two women is obviously pregnant and the other had had an operation because her spleen had burst when she ran into a parking pole, which is why her stomach was buttoned up. The masks I used came from some drawings I was making at the time that I felt would change the shape of the human figure if used with the addition of the photographically made eyes I glued to them. There's a connection here with Miró, African masks, and shields, for a face basically is what we project to the world or a shield is used as a kind of weapon of love or hate. I lit my models very much like a mug shot, or like an I.D. photograph is usually lit. The curious thing about this photograph, and many of the photographs I make, is that I can believe in something so crazy and preposterous as this image that exists only as a photograph."

One of Witkin's most gripping images is *Penitente,* 1982, which was taken when he was able to work with two dead Rhesus laboratory monkeys. "The nice thing about these Rhesus monkeys is the fact that they had had numbers put on their chests as codes. I really found that very appealing visually. I put numbers also on my model's chest. There are also appendages coming from his body. There are seeds from a tree that was growing outside my studio. I made the cross; it took me two days to make it because it had to be strong enough to hold up this guy who weighs almost 180 lbs. Then I crucified the monkeys on the crosses. I had done this with cats, that is driving nails through their 'hands,' and it's a very strong thing when you take a nail and put it through tissue. I'd be an evil person if I got pleasure out of doing this to a live person. However, if a person gets self-realization from having this done, and a person said, 'I want you to do this,' and I agreed to the idea, I wouldn't hesitate to do it.' " The basis of the allusion in this picture is the practice of New Mexico penitentes who flagellate themselves and tie male members of their religious order to a cross at Easter time in a re-creation of the crucifixion. In Witkin's picture the man's hands were not penetrated but held to the cross by leather

straps, and his weight was held up by a footrest. He explains: "He was screaming and wearing a skeleton mask that I modified to carry out my plan. I want to make it clear that I think it's a waste of real energy, real feelings, to demean yourself physically–to suffer–when there are different ways of generating a spiritual awareness. The picture in part is about the cruelty of crucifixion."

Pygmalion, (page 24) 1982, combines his interest in art history and personal expressionism. The image was created out of things around his studio including a fetus held up with string and wire. Because it is a constructed piece, the photograph exists as a record of what was put together and how it was put together; finally the construction hopefully transcends the way it was made. Witkin answered yes when asked, "Do you think of this work in terms of the death and destruction that took place when the German airforce bombed defenseless Guernica in the Spanish Civil War and Picasso's response to this event?" He replied, "All such things enter into my mind, but especially the way Picasso structured reality, giving an added note of poignancy by the use of the cadaver of the child."

One of Witkin's most powerful images is *Sanitarium,* (cover) 1983. He comments briefly about it as follows: "The tubes indicate the transfer of fluids running from the monkey's mouth and genitalia to the human. The wings are bird wings, and the mask is an old rubber mask turned inside out. I was reading some esoteric literature at the time about breathing in fumes and how such a sensation affects us. We cannot see such sensations, but I wanted to indicate them. I put this very large woman, who reminded me of the full-bodied women in Maillol's or Lachaise's work, in a languid pose. There is for me in this situation a strange, terrible sense of being forced to view the events in rooms of asylums or places of torture. But most importantly, it is a depiction of an egoless being, a shaman in existence here and beyond."

Alternates for Muybridge, 1984, relates to Witkin's interest in the past and in other art forms as well as to other artists who deal with the problems faced when creating conceptual pieces. He recalled: "When I was introduced to this very large woman, I could see beneath the dress she was wearing that she had an overlay of fat. This reminded me of a locomotion panel in Muybridge's[5] stop-action series in which he photographed a very heavy woman jumping. In the sequential panels we see bouncing up and down with her, almost separate from her body, the fat that enveloped her. I chose the model on the left with that historical connection in mind. The other figure is a pre-op transsexual. There is for me a kind of provocative fictional reference to time about the coming together of these two. I feel Muybridge would have used these people in his stop-action pictures if they had been available." Witkin also intended to refer to the social acceptance of such individuals, and what the acceptance of the body in all forms means for our society today. One should note that both individuals were posed in the same way with one hand on the hip and one hand down. Due to the breadth of the fat person, her gesture is quite different in effect than that of the transsexual, even though they are doing the same thing. When asked how the fat woman felt about this image, Witkin said, "She is a member of a very elite society of fat people and enjoys being the size she is, so does not mind being photographed."

Witkin recalls how he came to make *Choice of Outfits for the Agonies of Mary,* (page 41) 1984: "I came across a book of paper dolls that told readers how to dress dolls–I do that, too, I dress people." He continued in another direction: "I see everything in reference to the life of Christ–I see my own life, I see the different things I go through, not in a direct parallel but in a kind of medieval form of good/evil, and how a person seeks pleasure, and what that enjoyment means to them. I also can't forget that my mother's name is Mary. For this photograph I made sketches in San Francisco with all those S and M 'toys.' I had *boxes* of them loaned to me with different kinds of weapons, as well as devices of love and nourishment."

A recent photograph, *Harvest,* (page 43) 1984, signals Witkin's interest in a widening range of subjects. He comments on his photograph based on the sixteenth-century paintings of the Italian artist Archimboldo who made faces of fruits and vegetables: "I saw the head in a collection of medical oddities. It is a dry specimen made of wax around the turn of the century. I admired it the first time I saw it and asked the curator to ship it to me in New Mexico. Because of its delicacy and rareness, my request was refused. I therefore traveled to it. I felt I was on a pilgrimage, not to bring death back to life, but to show death's face as a witness to the supernatural. My wife and I spent six hours in selecting and placing the vegetables before the image was recorded on film. In addition to

being about death, this image also relates to the body's connection with food. The head, a very strange quiet thing, doesn't show violence although parts of the face and neck are exposed to show nerve endings and muscles where there had been connections to the rest of the body." In regard to the other elements in this composition, Witkin comments: "I often travel with things to be used in my images, on this occasion a piece of tree from the Southwest. For reasons I cannot quite explain it was important to use this in the arrangement. It turned out to be a good idea for it helped to hold the entire thing together."

Referring to Baron von Gloeden's photographs of young boys, Witkin comments on his 1984 picture, *von Gloeden in Asien* (page 32): "von Gloeden is my connection with male beauty, which we more and more realize has been with us from the time of the Greek pagan gods. My image is homoerotic, but a person who is not homosexual can also love the male body. I am interested in historic references, social references, and esthetic references. A photographic reality has a connection through a painting—a painting to a photograph again—that's a double value to me. And it's interesting how people's perception as viewers and creators of work change just because of the viability that they're exposed to by way of the quality of images they're addressing."

On a very recent trip to Florida, Witkin made contact with a number of circus and carnival people. He notes: "Unfortunately, a lot of such people are now dead. In fact sideshows and that part of circuses which include what is called freak shows are getting rarer. I went to Gibsontown, Florida, a place established by sideshow people to live in between tours or to retire to. The particular subject of my photograph lives there. He has been billed for many years as 'Melvin Burkhart: Human Oddity' (page 44). Part of his act was to drive an 8″ nail into his nose with a hammer. He made a living for forty years doing this. When he was young he was a prize-fighter and is still a very strong man. While fighting he had his nose broken many, many times, and eventually doctors had to take bone chips out of one nostril. When he was younger Burchart had seen a man drive a nail into his nose, and he realized after his nose operation that he could now do that. In his act he actually drove the nail into his head, just short of the braincase. I had him wear a mask and hood over his head to give the picture a sense of mystery and evoke the spirit of Lucifer."

Much of what Witkin deals with relates to death and sexual deviations from accepted mores. Such subjects shake up the residual puritanism in the middle class makeup. Many people pretend not to know about the phantasmagoric world he brings to life and rationalize the appetite for fetishistic death and sex as monstrous aberrations, thinking they only exist in the underground world of a few sin-ridden cities. Witkin's achievement in this respect is his ability to encapsulate in quite plausible terms the pungent, titillating, and sometimes eerie practices of masochism, mock mayhem, transvestism, and homosexual behavior carried out with Gothic appurtenances. We must remember that what he has recorded are in part figments of the photographer's imagination—as well as the fire and ice of real people. He demystifies taboos, scatology, and apocalyptic imagery. There are cases when his concoctions are undecipherable when first encountered, but, when we rub our eyes, the ominous implications of the underground world he pictures become more religious than threatening, more surreal than abnormal.

While often Witkin's pictures have the atmosphere of demonic fiction, this in part is due to the command he has over his imagination, and in part they are quite rational pokes at the philistines of the smug middle classes. However seemingly absurd Witkin's images are, we sense that they must be taken seriously for they derive from the realm we now associate with the Freudian subconscious where there is a constant hunger for sexual gratification, often coupled with rawness and even brutality. We are at the mercy of our fears which trigger the feeling of being powerless; an effect that, in the cold light of day, is out of proportion to the reality of the situations found in his pictures, but gives us clues to the sources of our deep-seated emotions.

It is no wonder that when encountering a group of Witkin's incendiary photographs, you might think for a moment that what you are seeing are freeze frames from a late night twilight-zone movie that started out as a "daydream" then unraveled to become a nightmare. However, he makes pictures of bizarre subjects not to shock but to cause us to ponder society's prohibitions and make us more aware of human needs. His pictures are neither parodies nor the results of feverish hallucinations but bold and haunting reflections of a world that exists all around the globe. In the climate of contemporary hedonism

his pictures, among other things, reflect a new openness to expressions of inner feelings, one's own and those of others.

Giving form to dreams, especially dreams that convey an aura of danger combined with the fantasies of sex, opens us up to ourselves and challenges long-held views. He initially drew upon his stock of mental images and sense of fantasy when fabricating situations or photographing people in role-playing encounters. Now he photographs real events. Some of the appeal of his pictures is in the sensation of seeing behind the curtain. The act of concealment is an enticement, for we all want to see what goes on during an initiation into a secret society, especially if there are intimations of sexual behavior or primitive rites. His work satisfies the need for some people to see shocking things so as to reaffirm their ability to respond to other human beings. His pictures provide us an armchair way of jolting one into a realization of sensations and desires that had not consciously entered our minds. For this reason his pictures seem demonic but at the same time humanistic; that is, we can empathetically respond in a personal way rather than in a scientific or cosmic fashion to his characterizations. Witkin is admirably inventive when it comes to giving us an intimate view of the dark side of our makeup. Most photographers have dealt with what is known. Witkin gives us glimpses of the unknown as he has "seen" it. He is not a stylist in the formal sense, nor is he a "modernist." Witkin connects with the past both in manners and philosophy to create a new iconography that relates to contemporary social behavior and the need he sees for revitalized spiritual content in art.

Van Deren Coke
Director
Department of Photography

Notes

1 Two of the Witkins in this exhibition are related to well-known nineteenth-century photographs, and one was inspired by a twentieth-century photograph. *The Prince Imperial* refers to Mayor frères and Pierson's 1860s studio portrait of Napoleon III's son sitting on a pony, and *Mandan* is based on George Catlin's painting of the 1830s of young Indian men being tested for bravery by being suspended in the air by cords hooked into their pectoral muscles. *Courbet in Rejlander's Pool* draws upon the work of the great nineteenth-century French realist painter and the Swedish-born British nineteenth-century genre photographer. A portrait by the twentieth-century German photographer August Sander is behind one of Witkin's images.

There are illustrated in this catalog Witkin's use of the painting *Don Manuel Osorio de Zuniga* by Goya and Grant Wood's 1930s portrait of his sister Nan. His parody of Ruben's 1630s painting of his beautiful wife, Helena Fourment, and Canova's nineteenth-century marble of *Venus* indicate that there is a whimsical side to Witkin. We look at these photographs derived from major works in art history and then look again to discover a penis peeking out from under the covers in Canova's *Paolina Borghese as Venus Victorious* and the same appurtenance appears attached to the coy *Helena Fourment* in Witkin's version. Much more serious in intent is his *Pygmalion* in which he incorporated imagery of a dead human fetus with portions of Picasso's great 1930s protest painting against war, *Guernica*.

2 Biographical information and quotations are derived from *Revolt Against the Mystical*, Witkin's M.A. Thesis, University of New Mexico, Albuquerque, 1976.

3 One of Witkin's teachers at the University of New Mexico, Thomas Barrow, was at this time scratching on *his* negatives in the series, *Cancellations*.

4 Further quotations are from an interview conducted by Van Deren Coke with Joel-Peter Witkin in Albuquerque, New Mexico, July, 1985.

5 Muybridge, Eadweard, *Animal Locomotion* (Philadelphia, 1887).

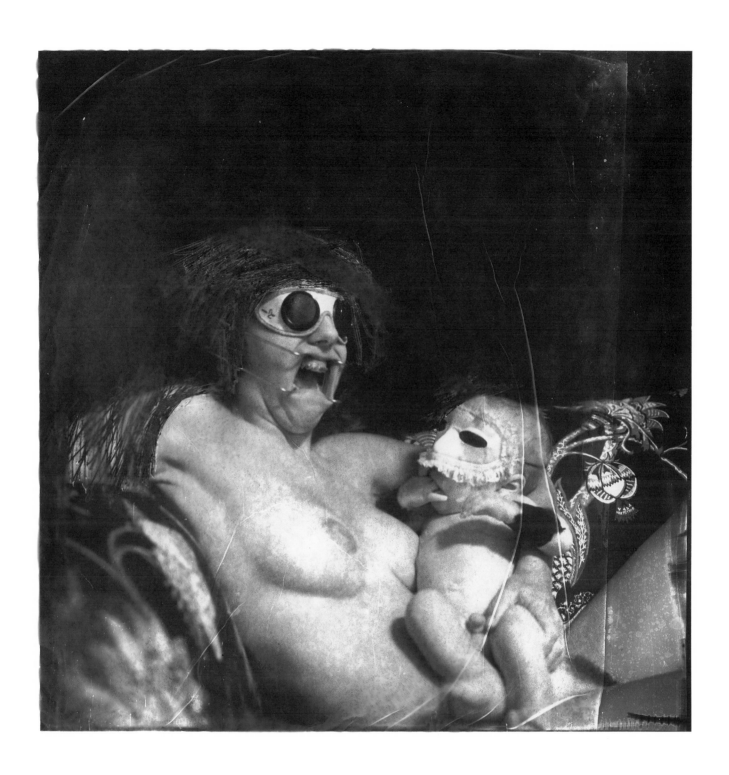

Mother and Child
1979/1982

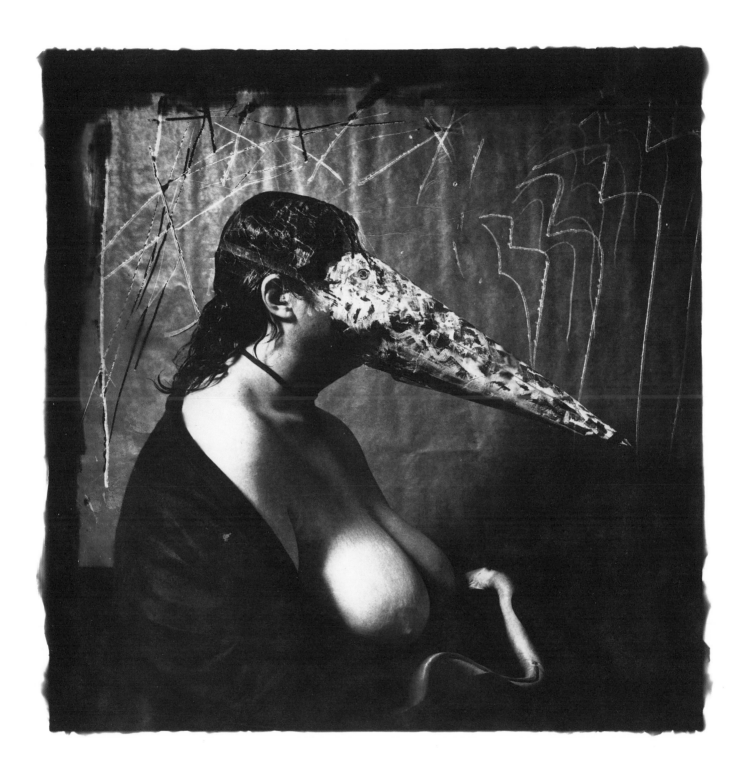

Woman Breastfeeding an Eel
1979

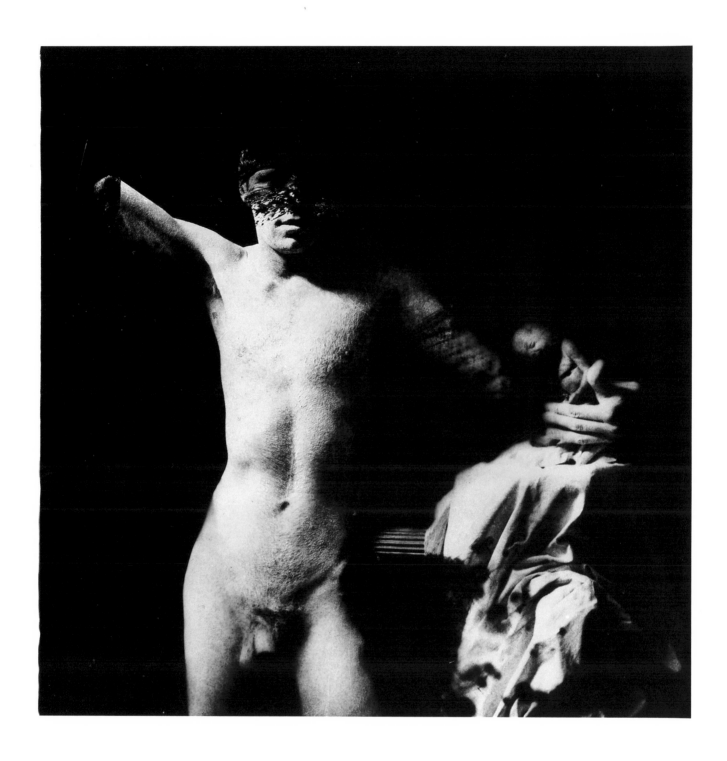

Hermes
1981

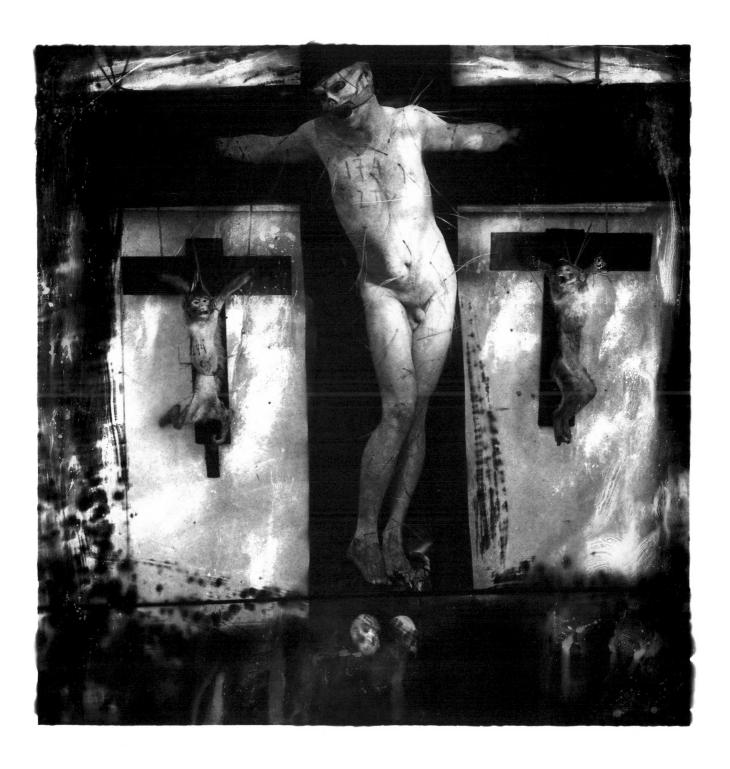

Penitente

1982

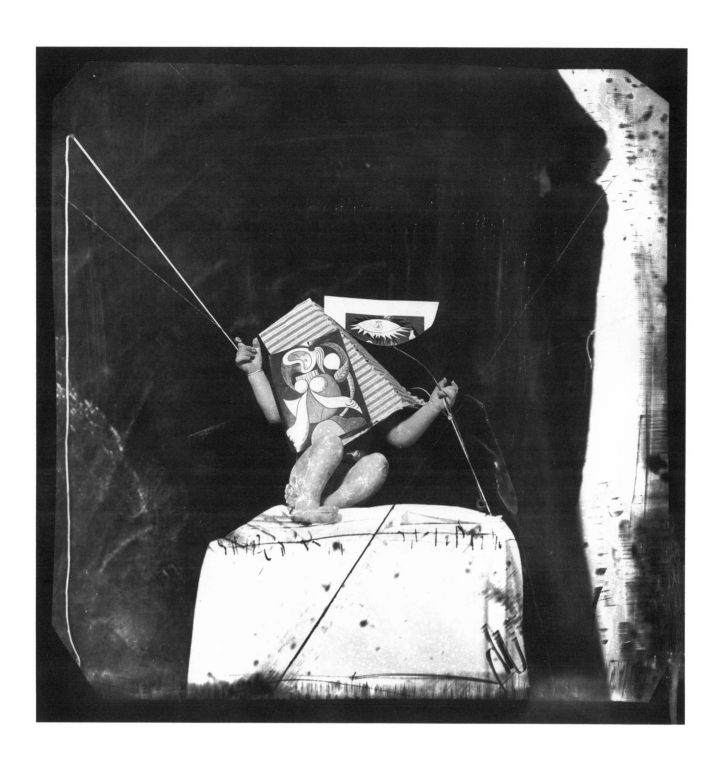

Pygmalion
1982

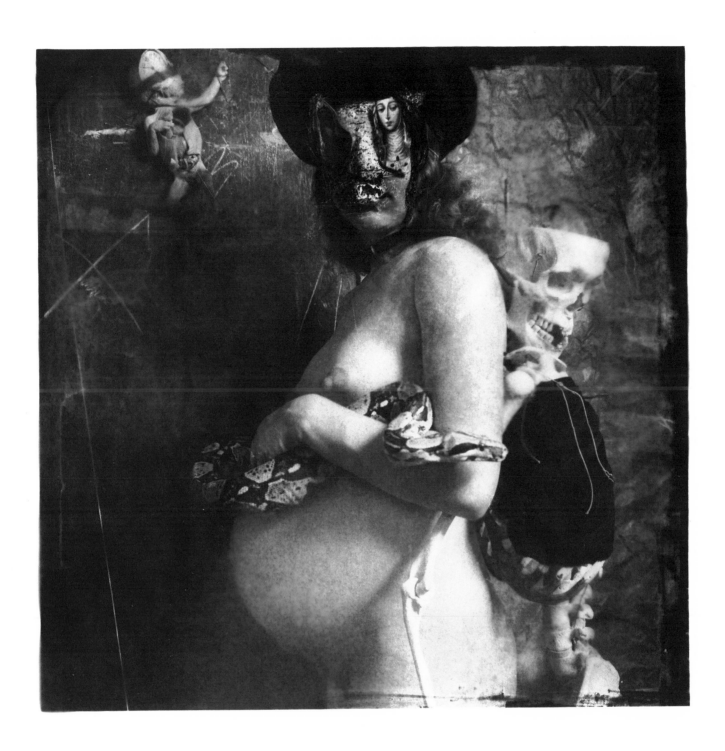

The Wife of Cain
1981/1982

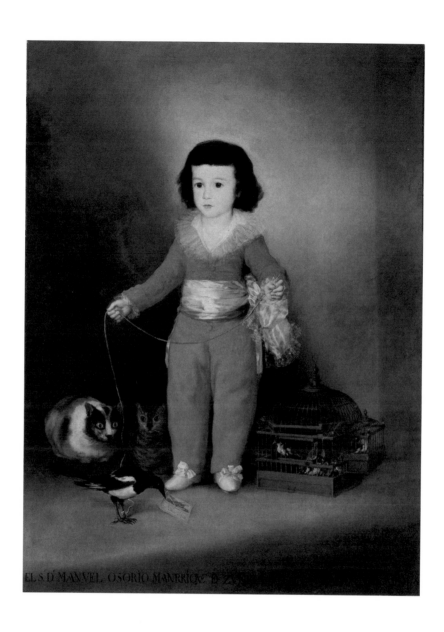

Francisco de Goya, *Don Manuel Osorio De Zuniga*, 1800,
oil on canvas, The Metropolitan Museum of Art, New York
(not in exhibition)

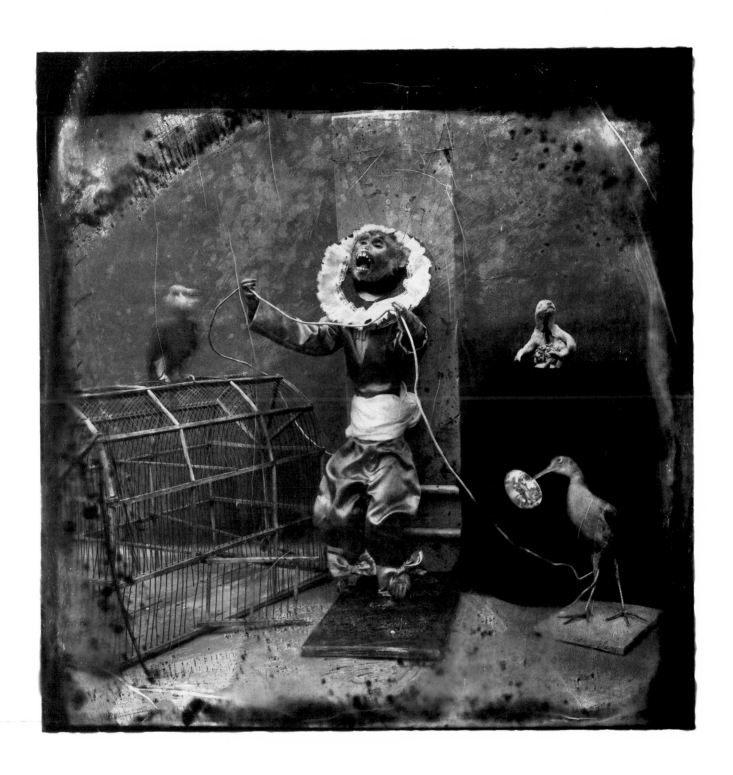

Manuel Osorio
1982

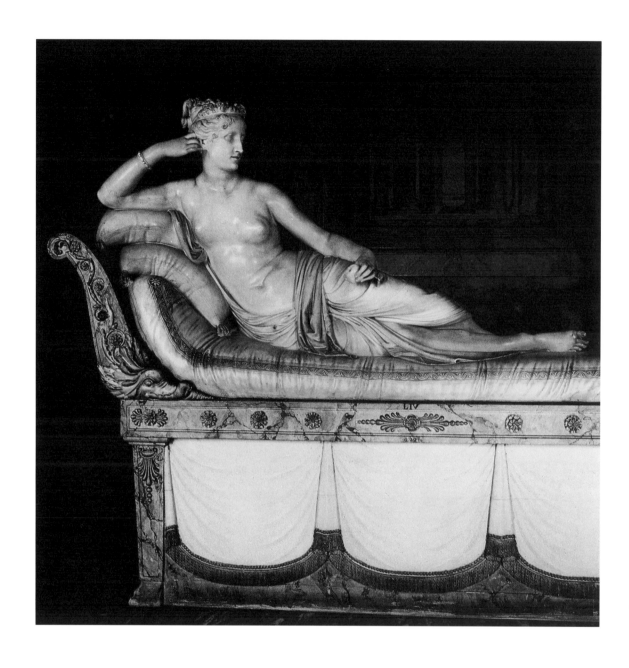

Canova, *Paolina Borghese as Venus Victorious*, 1804-8, marble,
Courtesy David Finn, New York
(not in exhibition)

Canova's Venus
1982

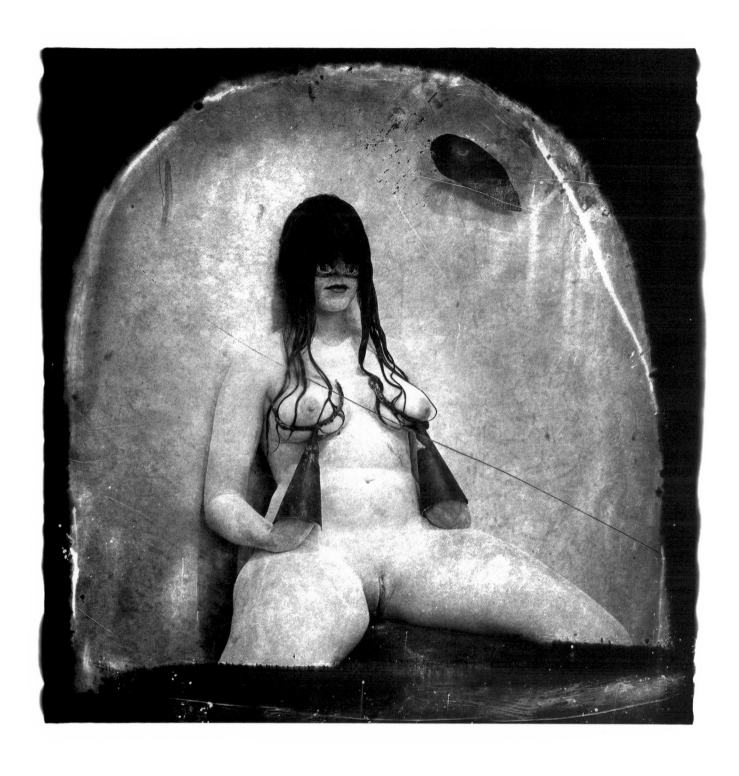

La Brassière de Joan Miró (The Bra of Joan Miró)
1982

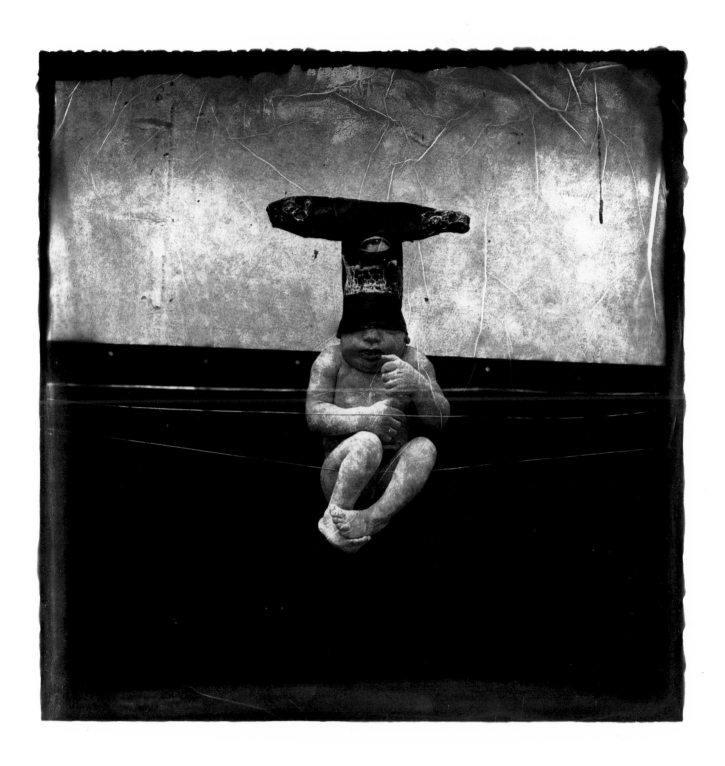

Counting Lesson in Purgatory
1982

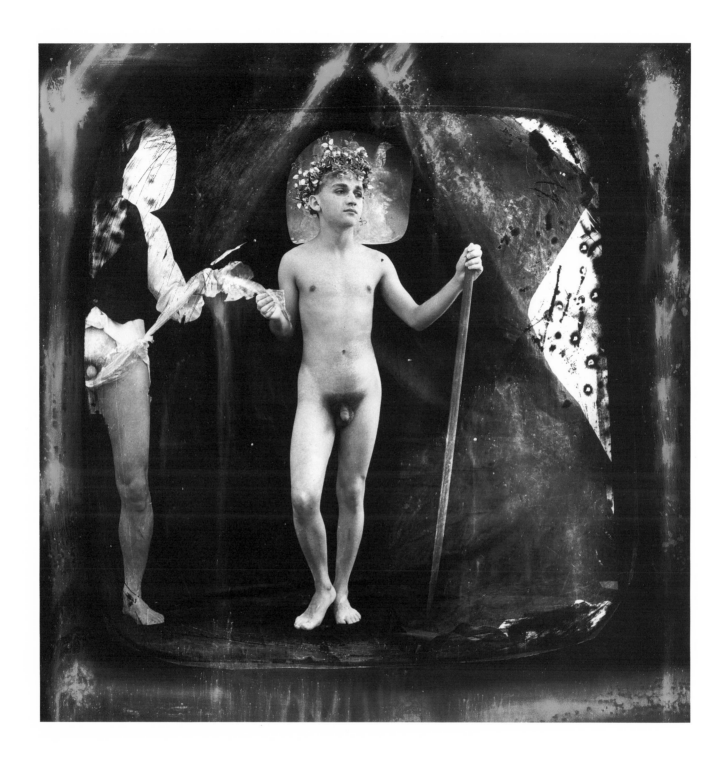

von Gloeden in Asien (von Gloeden in Asia)
1984

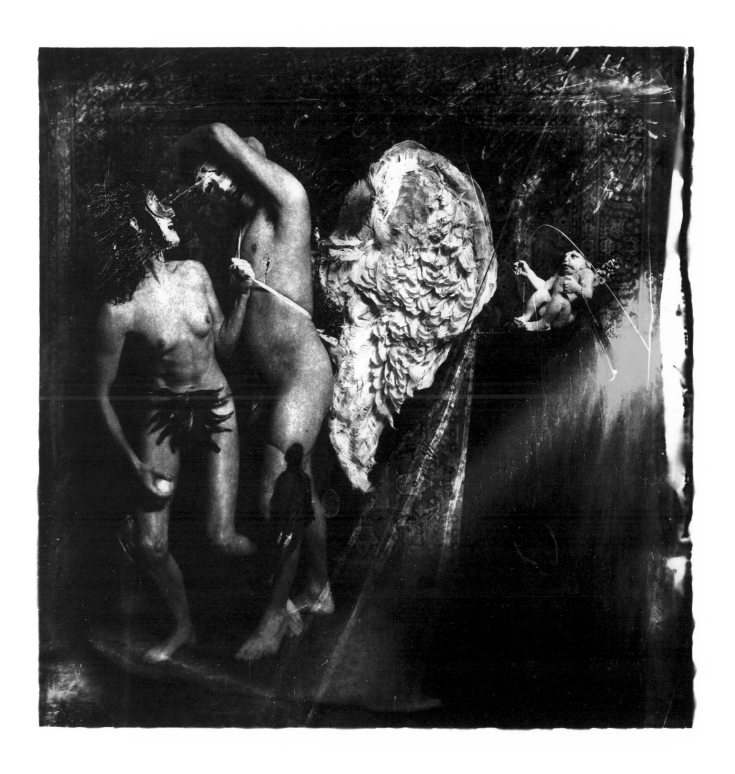

Expulsion from Paradise of Adam and Eve
1981

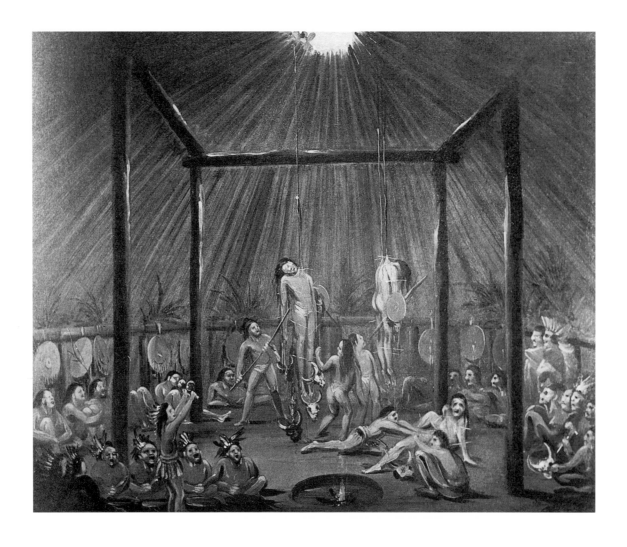

George Catlin, *The Cutting Scene, Mandan O-kee-pa ceremony*, 1832,
oil on canvas, W.D. Harmsen, Denver
(not in exhibition)

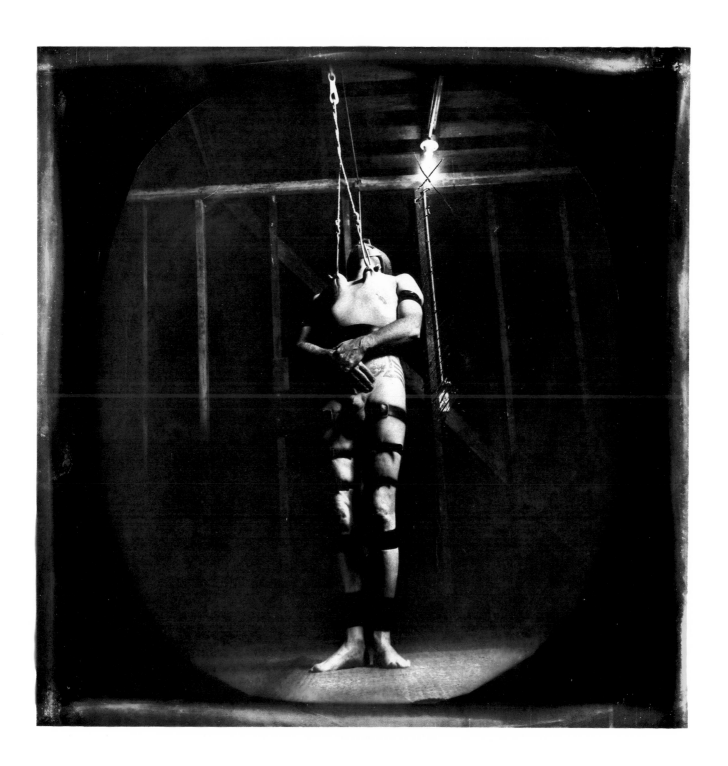

Mandan
1981

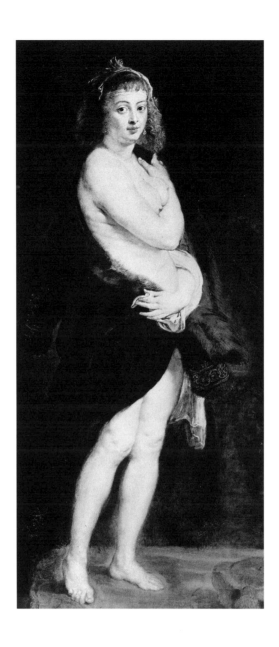

Peter Paul Rubens, *The Little Fur,* ca. 1638, oil on canvas,
Kunsthistorisches Museum, Vienna
(not in exhibition)

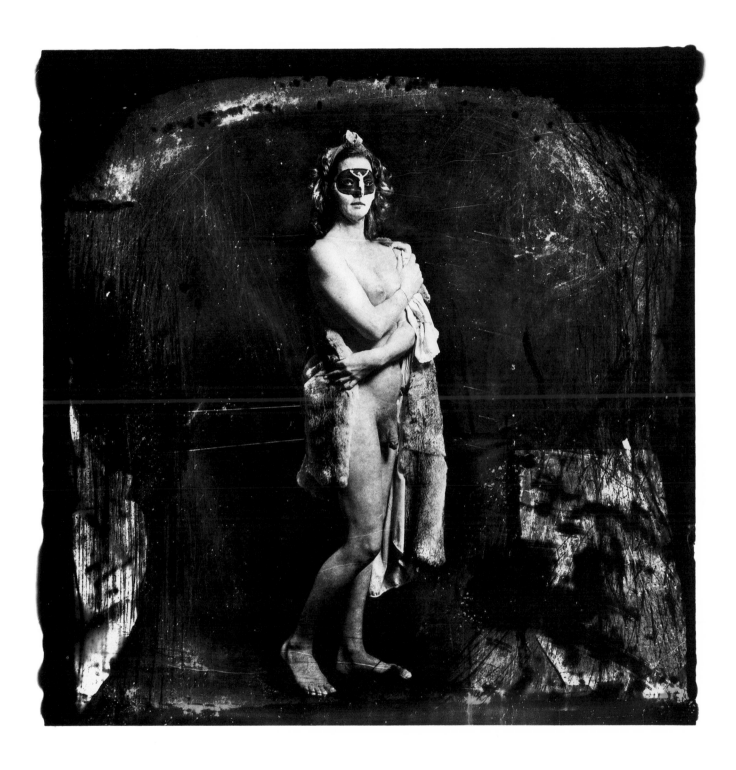

Helena Fourment

1984

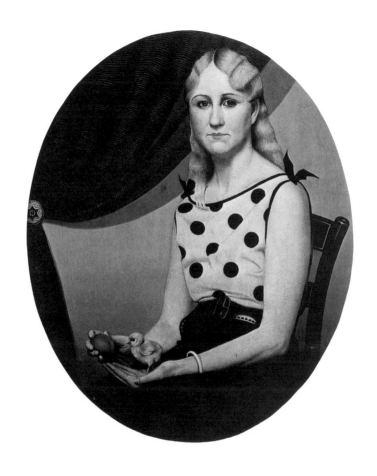

Grant Wood, *Portrait of Nan*, 1933, oil on masonite panel,
On loan to the Elvehjem Art Museum, University of Wisconsin, Madison
(not in exhibition)

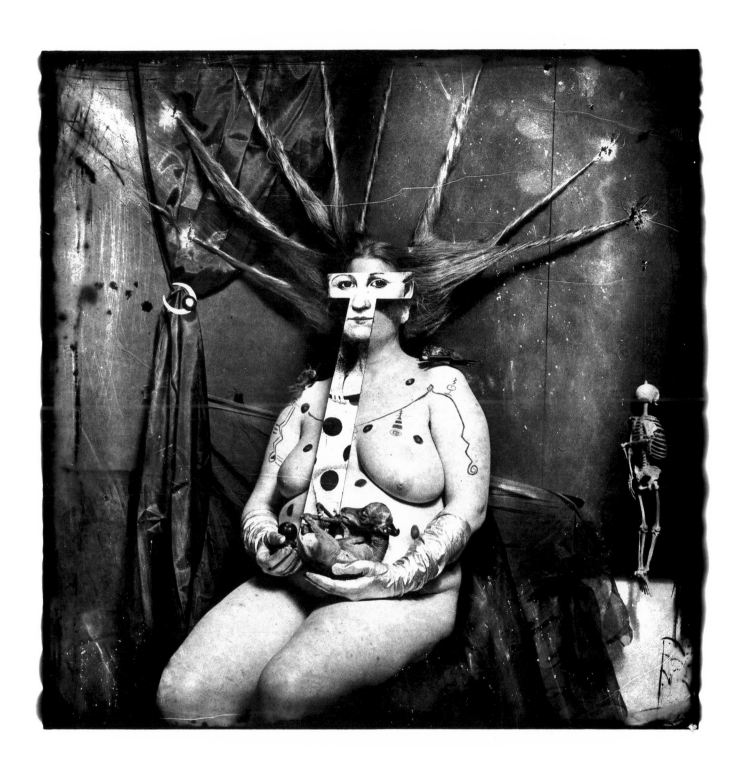

Portrait of Nan
1984

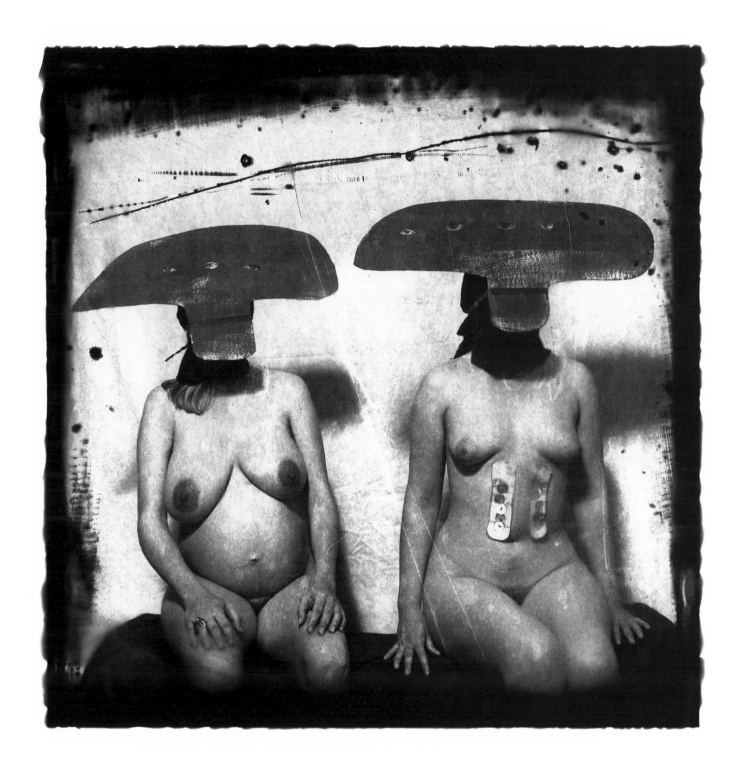

I.D. Photograph from Purgatory: Two Women with Stomach Irritations
1982

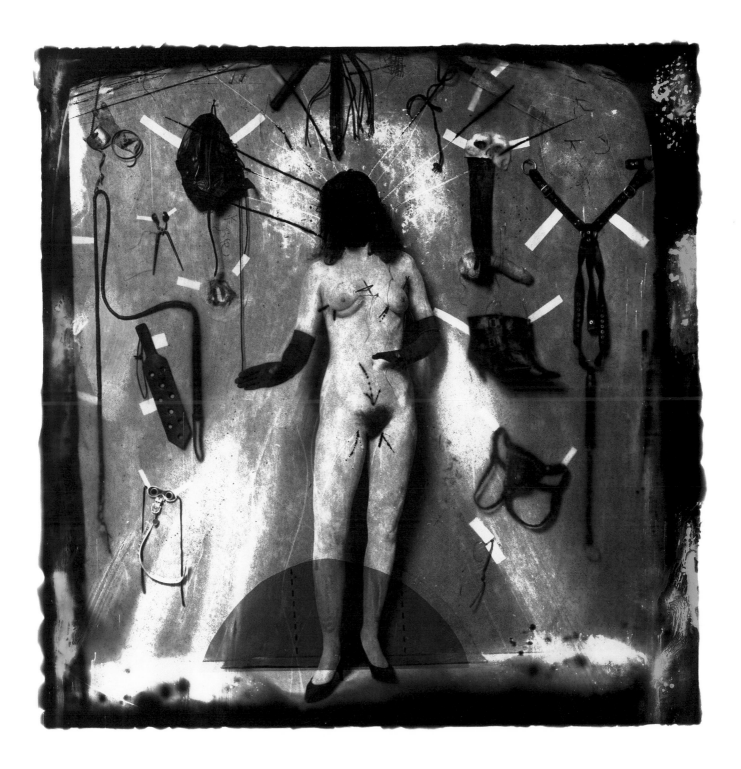

Choice of Outfits for the Agonies of Mary
1984

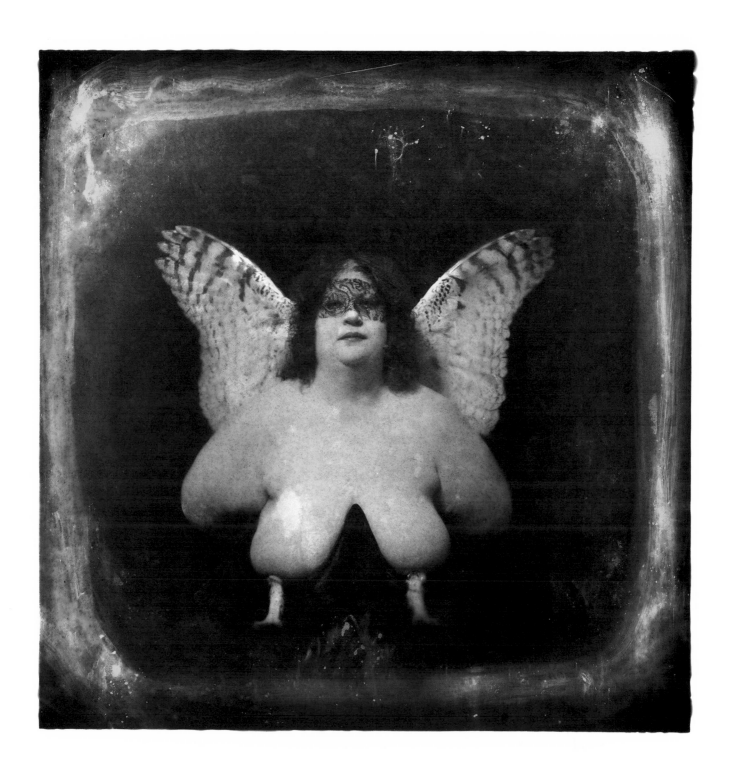

Bird of Queveda
1982

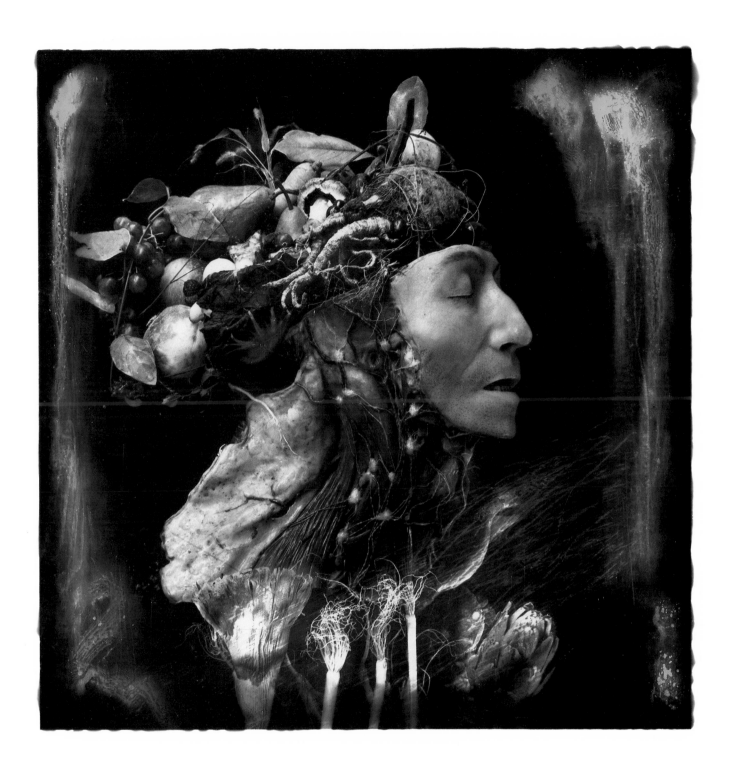

Harvest
1984

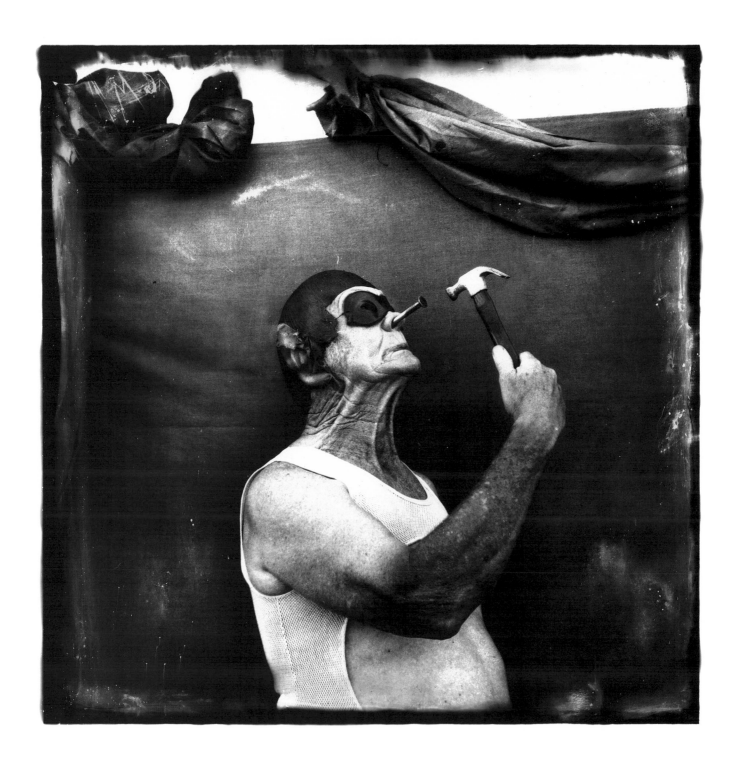

Melvin Burkhart Human Oddity
1985

In the listings of dimensions, height precedes width. Measurements indicate image size in inches; centimeter measurements are given in parentheses. Date refers to the date of the negative; when two are listed and separated by a slash, the second date is the date of the print. When known, print edition number is included. For some of the prints, the location where the photograph was taken is included in parentheses. Translations of foreign titles are italicized and also given in parentheses. When known, alternative titles under which the work has been previously published also appear in parentheses. All works are gelatin silver prints with selenium and sepia toners unless otherwise indicated.

Jesus and His Mother Mary: Photographed by an Anonymous Galilean Photographer, 1974, from the series, *Contemporary Images of Christ,* gelatin silver print, 6¹⁵⁄₁₆ x 4¾ (17.6 x 12.1), Collection of the artist

Two Women Bound (New Mexico), 1975, from the series, *Evidences of Anonymous Atrocities,* 15 x 15 (38.1 x 38.1), Jonathan Morgan, San Francisco

The Emperor of Japan (formerly *Untitled* [New Mexico]), 1977, gelatin silver print, from the series, *Objects Held and Thrown,* 8⁷⁄₁₆ x 12⅝ (21.5 x 32.1), San Francisco Museum of Modern Art, The Helen Crocker Russell and William H. and Ethel W. Crocker Family Funds Purchase 80.188

Man with Wings and Wheels (New Mexico), 1979, 11/15, 14⅝ x 14¹¹⁄₁₆ (37.1 x 37.3), Courtesy of Fraenkel Gallery, San Francisco, and Pace/MacGill Gallery, New York

Mother and Child (New Mexico), 1979/1982, 8/15, 14⅛ x 14⅜ (35.8 x 36.5), Courtesy of Fraenkel Gallery, San Francisco, and Pace/MacGill Gallery, New York

Woman Breastfeeding an Eel (New Mexico), 1979, 1/3, 28¼ x 38 (71.7 x 96.5), Courtesy of Fraenkel Gallery, San Francisco, and Pace/MacGill Gallery, New York

Carrotcake #1 (New Mexico), 1980/1982, 5/15, 14¹³⁄₁₆ x 14⅞ (37.6 x 37.8), Larry Phillips, Westport, California

Androgyny Breastfeeding a Fetus, 1981, 3/15, 14¼ x 14 (36.2 x 35.5), Courtesy of Fraenkel Gallery, San Francisco, and Pace/MacGill Gallery, New York

Angel of the Carrots (New Mexico), 1981, 12/15, 14¹¹⁄₁₆ x 14¹³⁄₁₆ (37.3 x 37.6), Mr. and Mrs. David C. Ruttenberg through the courtesy of the Ruttenberg Arts Foundation

Expulsion from Paradise of Adam and Eve (New Mexico), 1981, 1/15, 14¹⁵⁄₁₆ x 15 (38.0 x 38.1), Joel and Anne Ehrenkranz, New York

Hermes, 1981, a.p. I, 14¾ x14¾ (37.5 x 37.5), San Francisco Museum of Modern Art, Gift of Dr. and Mrs. William R. Fielder 84.210

Mandan (San Francisco), 1981, 2/15, 14¹¹⁄₁₆ x 14¹¹⁄₁₆ (37.3 x 37.3), Harry H. Lunn, Jr., Paris

The Prince Imperial (New Mexico), 1981, 12/15, 14¹⁵⁄₁₆ x 15 (38.0 x 38.1), Wallace S. Wilson, Houston

The Tests of Christ, Cicades (New Mexico), 1981, 7/15, 15 x 15¼ (38.1 x 38.7), Courtesy of Fraenkel Gallery, San Francisco, and Pace/MacGill Gallery, New York

The Wife of Cain (New Mexico), 1981/1982, 14⁷⁄₁₆ x 14¹³⁄₁₆ (36.6 x 37.6), Dr. Barry S. Ramer, San Francisco

Le Baiser (The Kiss) (New Mexico), 1982, a.p. I, 14¹³⁄₁₆ x 14¹⁵⁄₁₆ (37.6 x 37.9), Dr. and Mrs. William R. Fielder, Atherton, California

Bird of Queveda (New Mexico), 1982, 3/15, 14¹¹⁄₁₆ x 14¾ (37.3 x 37.4), Charles Schmalz, San Francisco

La Brassière de Joan Miró (The Bra of Joan Miró) (New Mexico), 1982, 3/15, 14½ x 14¾ (36.8 x 37.4) Mr. and Mrs. Richard Solomon, New York

Canova's Venus (New York), 1982, a.p. II, 14⅝ x 14¹³⁄₁₆ (37.2 x 37.7), San Francisco Museum of Modern Art, Gift of Dr. and Mrs. William R. Fielder 84.212

Capitulation of France (New Mexico), 1982, 14¾ x 15 (37.4 x 38.1), Charlene Engelhard, Cambridge, Massachusetts

Counting Lesson in Purgatory (New Mexico), 1982, 3/15, 14⅝ x 14½ (37.1 x 36.8), Helga Maaser, San Francisco

I.D. Photograph from Purgatory: Two Women with Stomach Irritations (New Mexico), 1982, 14⁷⁄₁₆ x 15 (36.6 x 38.1), Charlene Engelhard, Cambridge, Massachusetts

Manuel Osorio (New Mexico), 1982, 5/15, 14½ x 14 (36.8 x 35.5), Courtesy of Fraenkel Gallery, San Francisco, and Pace/MacGill Gallery, New York

Penitente (New Mexico), 1982, 14¹¹⁄₁₆ x 14¾ (37.3 x 37.4), Robert Pearlstein, New York

Pygmalion (New Mexico), 1982, 11/15, 14½ x 14¾ (36.8 x 37.4), René and Veronica di Rosa, Napa, California

Saviour of the Primates (New Mexico), 1982, 7/15, 14¹¹⁄₁₆ x 15 (37.3 x 38.1), René and Veronica di Rosa, Napa, California

Woman Masturbating on the Moon (New Mexico), 1982, 13/15, 14⁹⁄₁₆ x 14¾ (37.0 x 37.4), Jo C. Tartt, Jr., Washington, D.C.

Woman with Severed Head, 1982, 14⁷⁄₈ x 15 (37.8 x 38.1), Joseph and Elaine Monsen

Sanitarium (New Mexico), 1983, 3/3, 28½ x 28½ (72.4 x 72.4), Robert Lieber, San Francisco

Alternates for Muybridge (San Francisco), 1984, 1/15, 14¹⁵⁄₁₆ x 14¹⁵⁄₁₆ (38.0 x 38.0), Courtesy of Fraenkel Gallery, San Francisco, and Pace/MacGill Gallery, New York

Choice of Outfits for the Agonies of Mary (San Francisco), 1984, 14½ x 14¾ (36.8x 37.4), Robert Pearlstein, New York

Drawing for Helena Fourment (San Francisco), 1984, from the series, *Journeys of the Mask,* pencil on paper, 7½ x 8 (19.0 x 20.3), Courtesy of Fraenkel Gallery, San Francisco, and Pace/MacGill Gallery, New York

Harvest (Philadelphia), 1984, 3/3, 28 x 28 (71.1 x 71.1), Mr. and Mrs. Arthur Goldberg, New York

Helena Fourment (San Francisco), 1984, 3/3, from the series, *Journeys of the Mask,* 28 x 28 (71.1 x 71.1), Courtesy of Galerie Texbraun, Paris

Portrait of Nan (New Mexico), 1984, 2/3, 29¼ x 29¼ (74.3 x 74.3), Byron Meyer, San Francisco

Il Ragazzo con Quattro Bracci (The Boy with Four Arms) (San Francisco), 1984, 1/15, 14⅝ x 15¹⁄₁₆ (37.1 x 38.2), Joshua Smith, Washington, D.C.

The Result of War: Cornucopian Dog (New Mexico), 1984, 2/3, 28 x 28⅛ (71.7 x 71.4), Bruce Velick, San Francisco

von Gloeden in Asien (von Gloeden in Asia) (New York), 1984, 4/15, 14¹⁵⁄₁₆ x 14⅝ (38.0 x 37.1), Joshua Smith, Washington, D.C.

Courbet in Rejlander's Pool (New Mexico), 1985, 3/15, 14⁷⁄₈ x 14⁷⁄₈ (37.8 x 37.8), Courtesy of Fraenkel Gallery, San Francisco, and Pace/MacGill Gallery, New York

Melvin Burkhart Human Oddity (Florida), 1985, 1/15, 14¾ x 14¾ (37.4 x 37.4), Courtesy of Fraenkel Gallery, San Francisco, and Pace/MacGill Gallery, New York

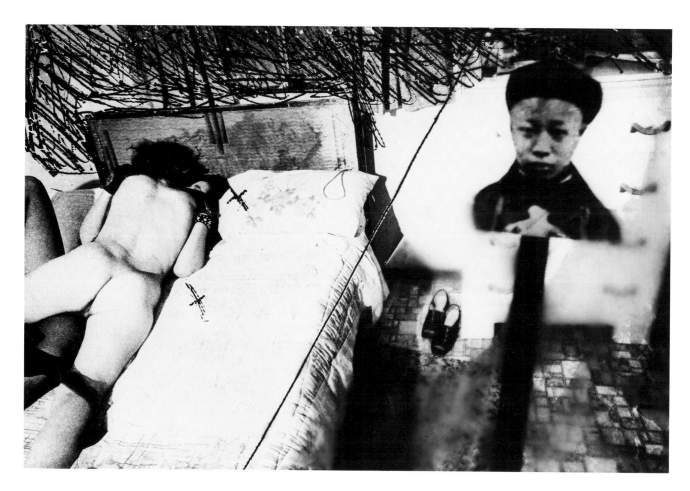

The Emperor of Japan
1977

Born in Brooklyn, New York, 1939
Studied at The Cooper Union School
of Art, New York (B.A., 1974); University
of New Mexico, Albuquerque (M.A., 1976)

Selected One-Person Exhibitions

1969 Moore College of Art Gallery,
Philadelphia

1972 The Cooper Union School of Art,
New York

1976 University Art Museum, University
of New Mexico, Albuquerque

1980 Projects Studio One, New York

1982 Fraenkel Gallery, San Francisco
Galerie Texbraun, Paris
San Francisco Camerawork

1983 C.E.P.A. Gallery, Buffalo, New York
Kansas City Art Institute, Missouri
Provinciaal Museum voor Actuele
Kunst, Hasselt, Belgium
Stedelijk Museum, Amsterdam
(catalog)

1984 Fraenkel Gallery, San Francisco
Pace/MacGill Gallery, New York
Paul Cava Gallery, Philadelphia

1985 *The Unique Vision of Joel-Peter Witkin,*
The Aspen Art Museum, Colorado
Butler Gallery, Houston
FIAC 85, Galerie Texbraun,
at the Grand Palais, Paris
Galerie Watari, Tokyo
Institute Franco-American, Paris
Pace/MacGill Gallery, New York

Selected Group Exhibitions

1976 *1976 Exhibition of American Photog-
raphy,* Andromeda Gallery Ltd.,
New York (catalog)
Light Work Community Darkroom,
Syracuse, New York
New Photographics/76, Central
Washington State University,
Ellensburg (catalog)

1977 *18 CAPS Photographers,*
The Aldrich Museum of Contemporary
Art, Ridgefield, Connecticut
Photoerotica, San Francisco Camerawork

1980 *Contemporary Photographers of New
Mexico,* The Art Institute of Chicago

1981 *The Markers,* San Francisco
Museum of Modern Art (catalog)
Photographer as Printmaker, Ferens
Art Gallery, Hull, England (catalog)

1982 *Androgeny in Art,* Emily Lowe
Gallery, Hofstra University,
Hempstead, New York
Form, Freud and Feeling, San
Francisco Museum of Modern Art
Mois de la Photo à Paris, Musée
Nationale d'Art Moderne et de
Centre Georges Pompidou, Paris
New New York, Fine Arts Gallery,
Florida State University, Tallahassee
(catalog)
Staged Photo Events,
Kuntstichting, Rotterdam,
The Netherlands (catalog)

1983 *Images Fabriquées,* Centre Georges
Pompidou, Paris (catalog)
Personal Choice, Victoria and Albert
Museum, London

1984 *Content: A Contemporary Focus,
1974-1984,* Hirshhorn Museum and
Sculpture Garden, Smithsonian
Institution, Washington, D.C. (catalog)
The Directed Image, G.H. Dalsheimer
Gallery, Baltimore
Fifth Anniversary Exhibition,
Fraenkel Gallery, San Francisco
*The Human Condition:
A Psychiatrist's Perspective, Selections
from the Ramer Collection,*
San Francisco Museum of Modern
Art (catalog)
*The Human Condition: SFMMA
Biennial III,* San Francisco Museum
of Modern Art (catalog)
*Radical Photography–The Bizarre
Image,* Nexus Gallery, Atlanta

1985 *American Images: Photography
1945-1980,* Barbican Art Gallery,
London
Biennial Exhibition,
Whitney Museum of American Art,
New York (catalog)
*Extending the Perimeters of Twentieth-
Century Photography,* San Francisco
Museum of Modern Art (catalog)
The Sam Wagstaff Collection, Interna-
tional Center of Photography,
New York
*Signs of the Times: Some Recurring
Motifs in Twentieth-Century Photogra-
phy,* San Francisco Museum of
Modern Art (catalog)

Selected Bibliography

Albright, Thomas. "Perversely Fas-
cinating Nightmares." *San Francisco
Chronicle,* 30 July 1983, p. 33.

Badger, Gerald. "Beyond Arbus
and Bacon–The Photographs of
Joel-Peter Witkin." *Zien* 5, 1983,
p. 20.

Edwards, Owen. "Dancing with
Death." *American Photographer,*
August 1983, pp. 29-30.

Edwards, Owen. "Joel-Peter
Witkin." *American Photographer,*
November 1985, pp. 40-53.

Fahey, David. "Joel-Peter Witkin."
Interview, July 1985, pp. 103-105.

Fischer, Hal. "Joel-Peter Witkin:
The Dark End of the Spectrum."
Fotografie 32-33, 1984, pp. 30-37.

Kozloff, Max. "Contention between
Two Critics about a Disagreeable
Beauty." *Artforum,* February 1984,
pp. 45-53.

Witkin, Joel-Peter. "Divine Revolt."
Aperture, Fall 1985, pp. 34-41.

Permanent Collections

The Albuquerque Museum,
New Mexico

Akron Art Museum, Ohio

The Allen Memorial Art Museum,
Oberlin College, Ohio

The Art Museum, Princeton
University, New Jersey

Bibliothéque Nationale, Paris

High Museum of Art, Atlanta

International Museum of Photogra-
phy at George Eastman House,
Rochester, New York

The J. Paul Getty Museum,
Malibu, California

Kansas City Art Institute, Missouri

The Museum of Modern Art,
New York

Musée Nationale d'Art Moderne et
de Centre Georges Pompidou, Paris

San Francisco Museum of
Modern Art

Stedelijk Museum, Amsterdam

University Art Museum, University
of New Mexico, Albuquerque

Victoria and Albert Museum,
London

BOARD OF TRUSTEES AND STAFF